MALALA YOUSAFZAI

ACTIVIST FOR PEACE AND EDUCATION

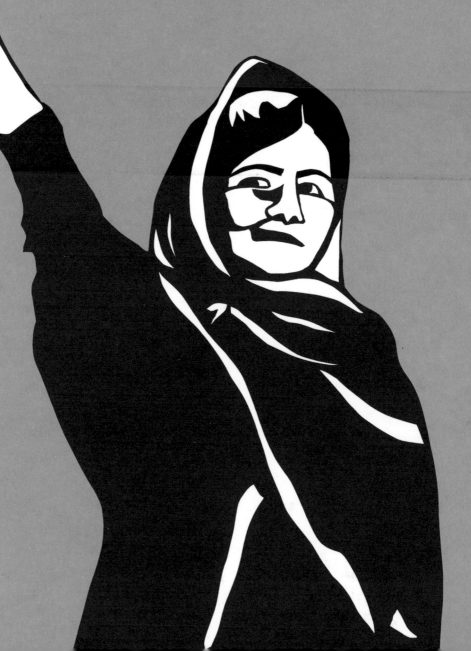

"WHEN THE WHOLE WORLD IS SILENT, EVEN ONE VOICE BECOMES POWERFUL."

—MALALA YOUSAFZAI

JULY 12, 1997 (MINGORA, PAKISTAN)

JUNKO TABEI

FIRST WOMAN TO CLIMB MOUNT EVEREST

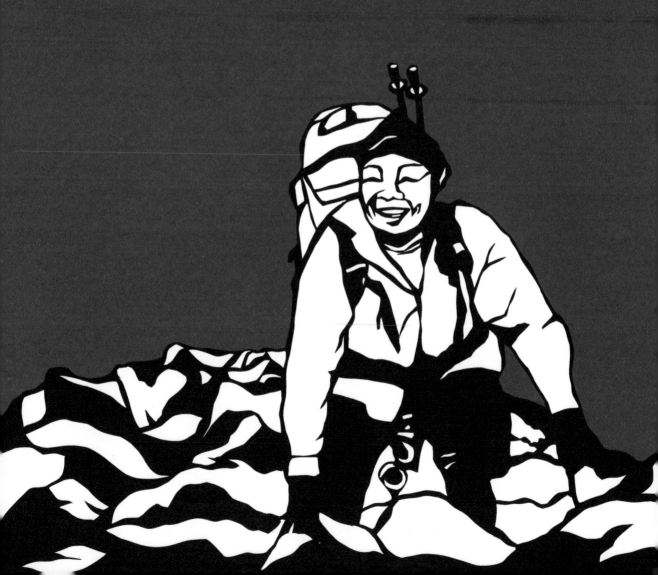

"There was never a question in my mind that

I WANTED TO CLIMB THAT MOUNTAIN, NO MATTER WHAT OTHER PEOPLE SAID."

—JUNKO TABEI

SEPTEMBER 22, 1939 (MIHARU, JAPAN)–OCTOBER 20, 2016 (KAWAGOE, JAPAN)

KALPANA CHAWLA

FIRST INDIAN WOMAN IN SPACE

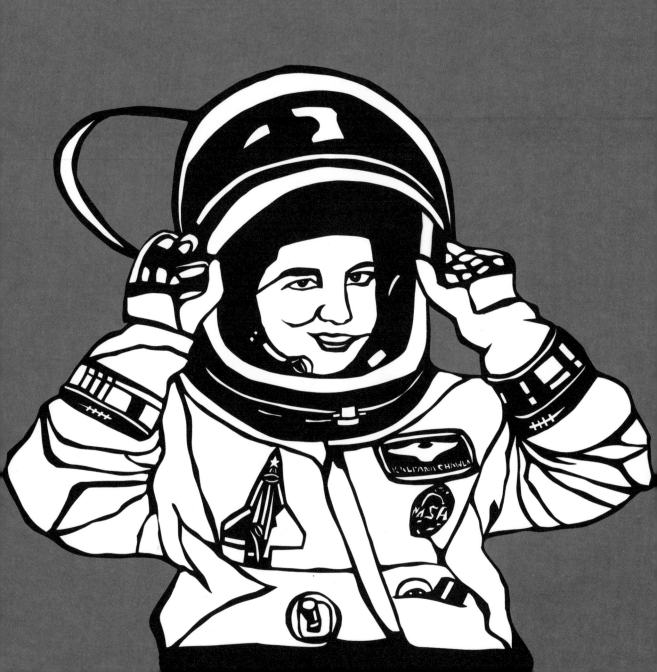

"THE PATH FROM DREAMS TO SUCCESS DOES EXIST.

May you have the vision to find it, the courage to get onto it, and the perseverance to follow it."

—KALPANA CHAWLA

MARCH 17, 1962 (KARNAL, INDIA)—FEBRUARY 1, 2003 (TEXAS, U.S.A.)

FAITH BANDLER

ACTIVIST AND ADVOCATE FOR INDIGENOUS AUSTRALIANS

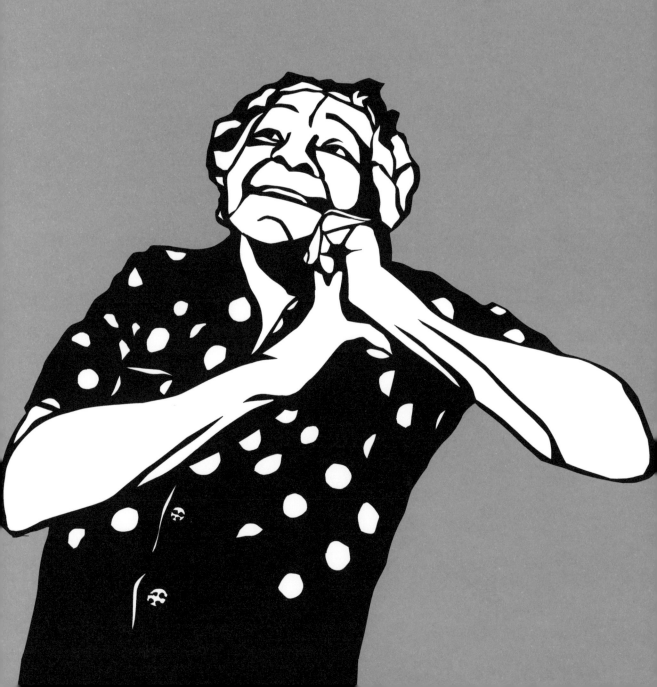

"I WORKED VERY HARD, EVERY DAY OF THE WEEK."

—FAITH BANDLER

SEPTEMBER 23, 1918 (TUMBULGUM, NEW SOUTH WALES, AUSTRALIA)–
FEBRUARY 13, 2015 (SYDNEY, NEW SOUTH WALES, AUSTRALIA)

MIRIAM MAKEBA

SOUTH AFRICAN SINGER AND ANTI-APARTHEID ACTIVIST

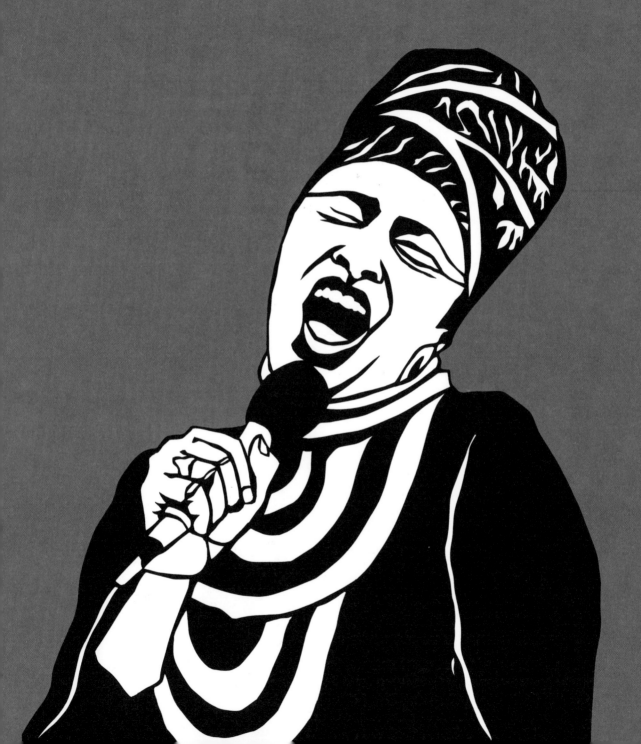

"I'M GOING TO GO ON SINGING, TELLING THE TRUTH."

—MIRIAM MAKEBA

MARCH 4, 1932 (JOHANNESBURG, SOUTH AFRICA)–NOVEMBER 9, 2008 (CASTEL VOLTURNO, ITALY)

LIV ARNESEN AND ANN BANCROFT

FIRST WOMEN TO TREK ACROSS ANTARCTICA

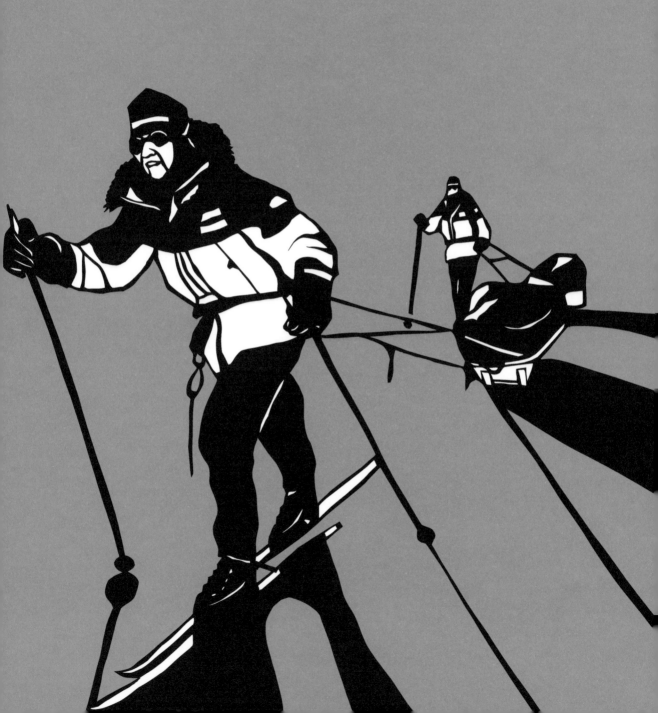

"WHEN YOU FEEL YOUR HEART BEATING HARD OR YOUR BLOOD RUNNING FAST, YOU HAVE FOUND SOMETHING THAT IS IMPORTANT TO YOU. CREATE ROOM FOR IT."

—LIV ARNESEN

LIV: JUNE 1, 1953 (BÆRUM, NORWAY)
ANN: SEPTEMBER 29, 1955 (ST. PAUL, MINNESOTA, U.S.A.)

JOSEPHINE BAKER

ENTERTAINER, ACTOR, HUMANITARIAN—AND SPY!

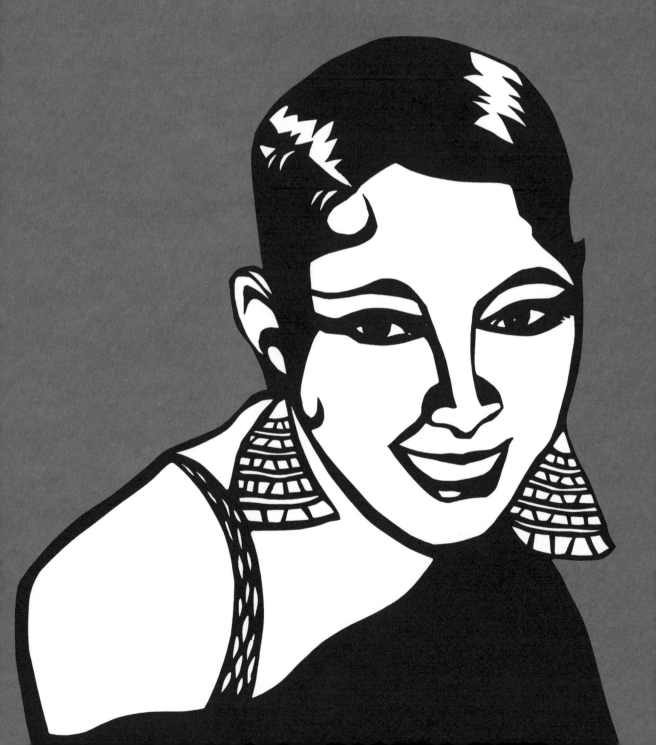

"Not everybody has the same color, the same language, or the same customs, but they have the

SAME HEART, THE SAME BLOOD, & THE SAME NEED FOR LOVE."

—JOSEPHINE BAKER

JUNE 3, 1906 (ST. LOUIS, MISSOURI, U.S.A.)–APRIL 12, 1975 (PARIS, FRANCE)

WANGARI MAATHAI

NOBEL PRIZE–WINNING ENVIRONMENTAL ACTIVIST

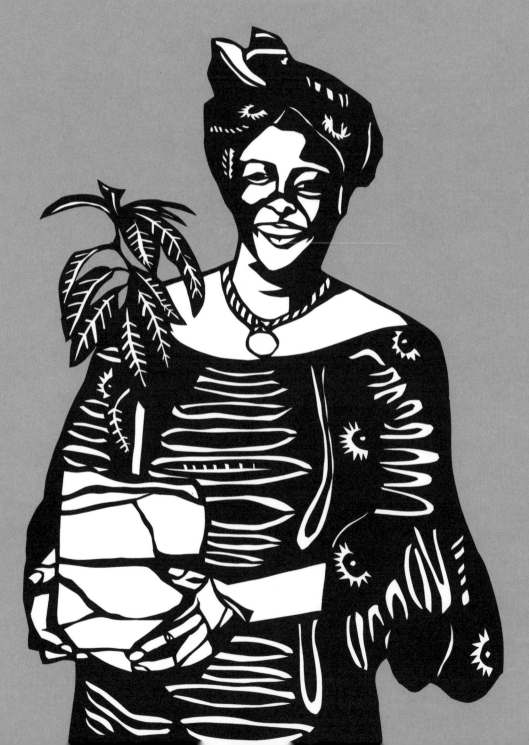

"When we plant trees,

WE PLANT THE SEEDS OF PEACE & SEEDS OF HOPE."

—WANGARI MAATHAI

APRIL 1, 1940 (NYERI, KENYA)–SEPTEMBER 25, 2011 (NAIROBI, KENYA)

FRIDA KAHLO

INTERNATIONALLY CELEBRATED PAINTER

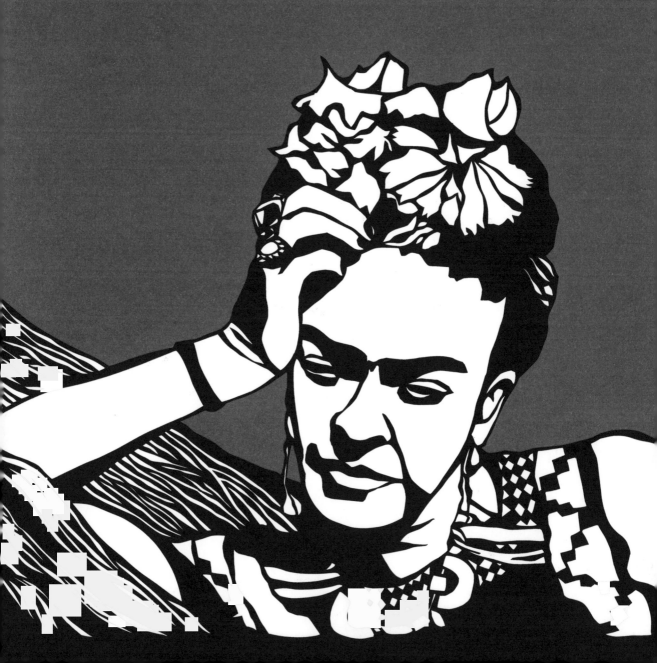

"I AM HAPPY TO BE ALIVE AS LONG AS I CAN PAINT."

—FRIDA KAHLO

JULY 6, 1907–JULY 13, 1954 (COYOACÁN, MEXICO)

QUEEN LILI'UOKALANI

FIRST AND FINAL QUEEN OF THE KINGDOM OF HAWAII

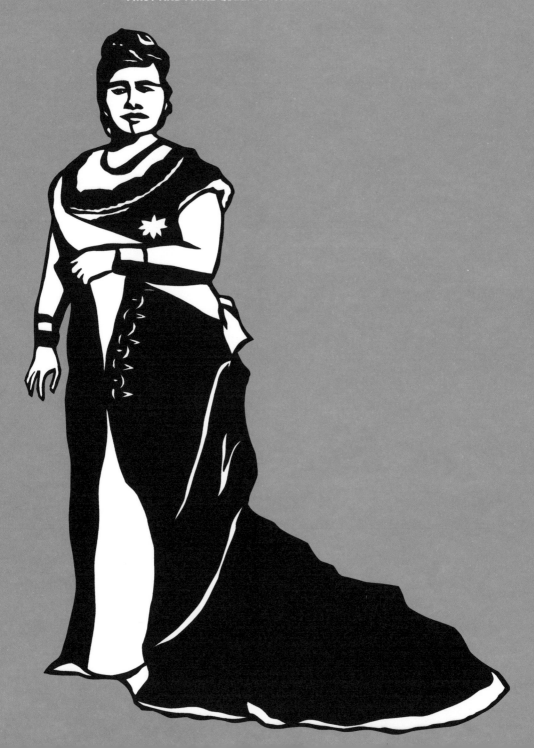

"You must remember

NEVER TO CEASE TO ACT BECAUSE YOU FEAR YOU MAY FAIL."

—QUEEN LILI'UOKALANI

SEPTEMBER 2, 1838–NOVEMBER 11, 1917 (HONOLULU, HAWAII)

NANNY OF THE MAROONS

NATIONAL HERO OF JAMAICA

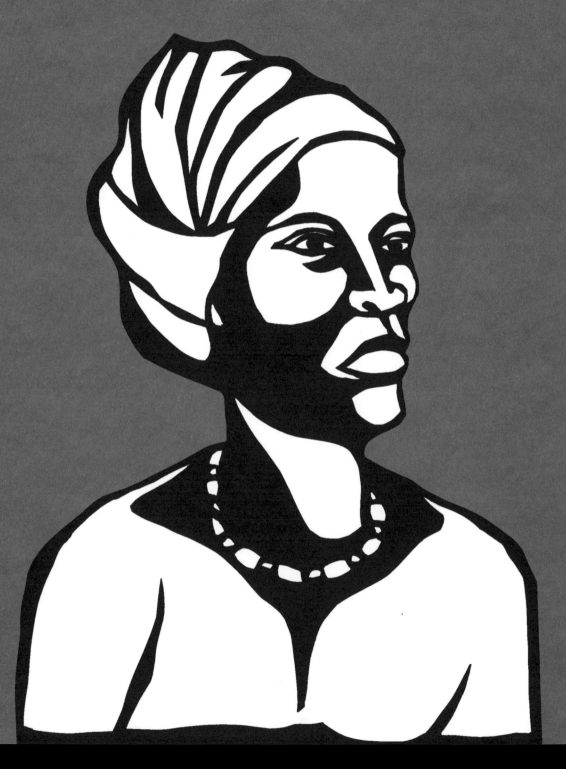

"Nanny and the people now residing with her and **THEIR HEIRS ARE GRANTED... A CERTAIN PARCEL OF LAND.**"

—FROM A 1739 TREATY

NANNY OF THE MAROONS

APPROXIMATELY 1685 (GHANA)–APPROXIMATELY 1755 (JAMAICA)

VENUS AND SERENA WILLIAMS

WORLD-CHAMPION TENNIS PLAYERS AND SISTERS

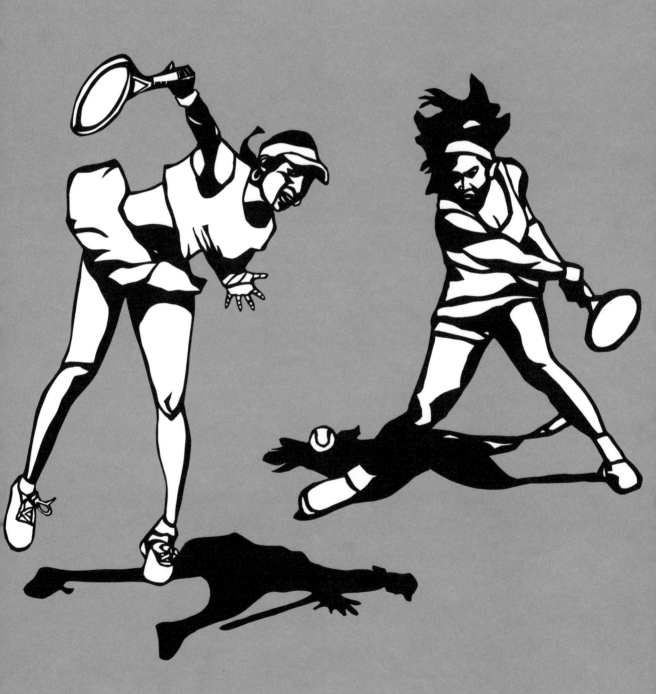

"MY MOM RAISED US TO BE STRONG WOMEN."

—VENUS WILLIAMS

VENUS: JUNE 17, 1980 (LYNWOOD, CALIFORNIA, U.S.A.)
SERENA: SEPTEMBER 26, 1981 (SAGINAW, MICHIGAN, U.S.A.)

EMMA GOLDMAN

ANARCHIST, POLITICAL ACTIVIST, AND WRITER

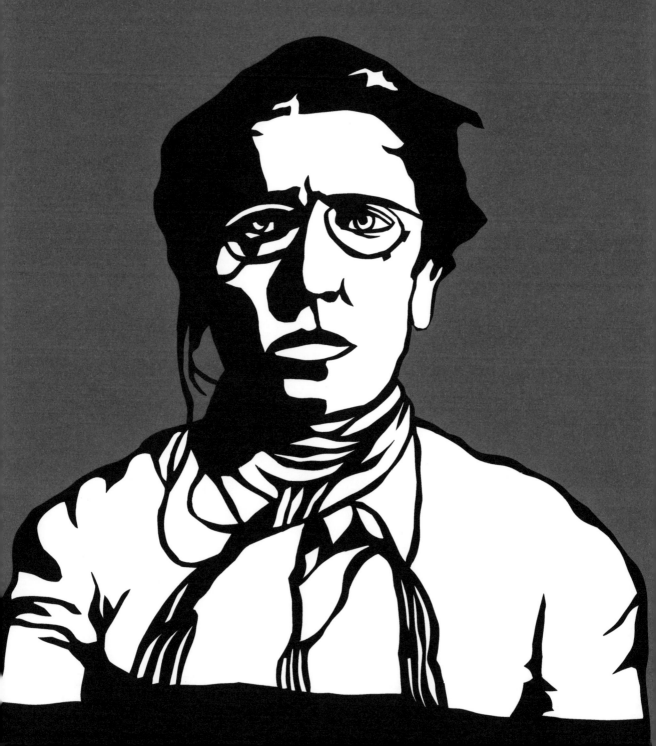

"I WANT FREEDOM, THE RIGHT TO SELF-EXPRESSION, EVERYBODY'S RIGHT TO BEAUTIFUL, RADIANT THINGS."

—EMMA GOLDMAN

JUNE 27, 1869 (KOVNO, RUSSIA)–MAY 14, 1940 (TORONTO, CANADA)

HATSHEPSUT

FIRST FEMALE KING OF EGYPT

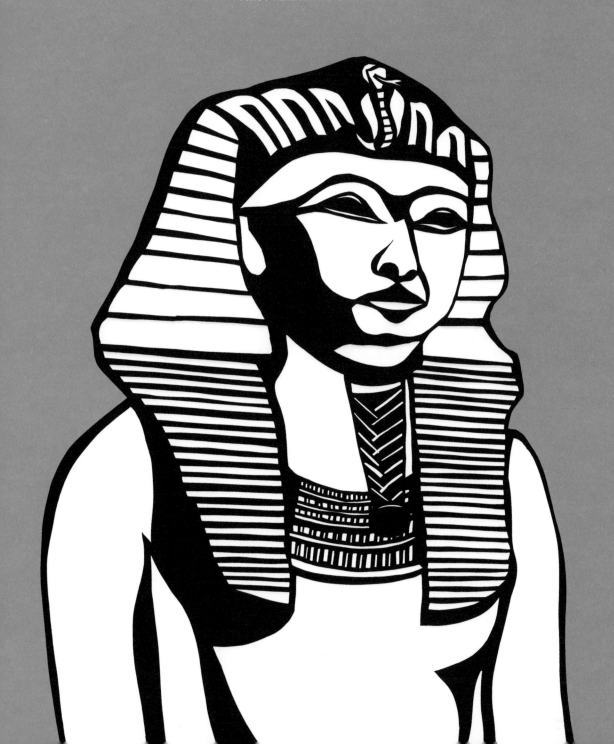

"Now my heart turns this way and that, as I think what the people will say. Those who see my monuments in years to come, and

WHO SHALL SPEAK OF WHAT I HAVE DONE."

—HATSHEPSUT

1508–1458 BCE (EGYPT)

SOPHIE SCHOLL

ANTI-NAZI STUDENT ACTIVIST

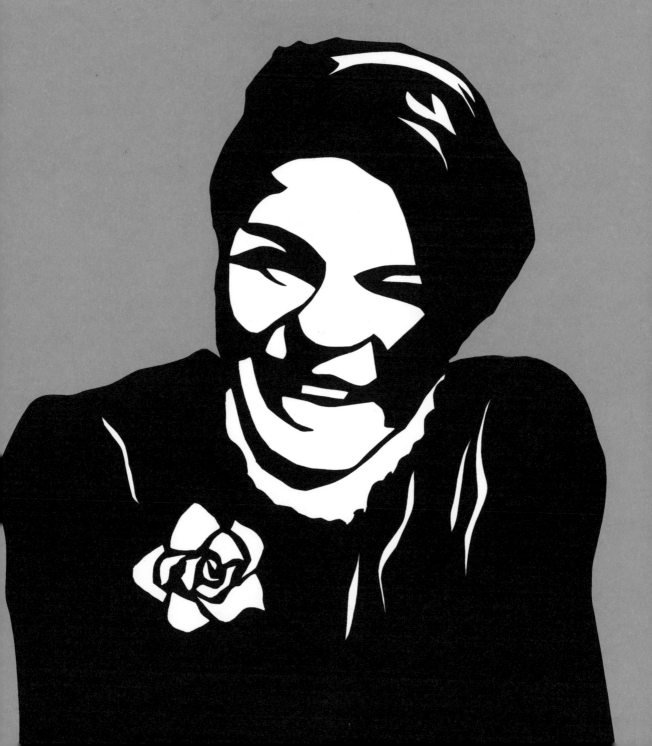

"WHAT WE DID WILL CAUSE WAVES."

—SOPHIE SCHOLL

MAY 9, 1921 (FORCHTENBERG, GERMANY)—FEBRUARY 22, 1943 (MUNICH, GERMANY)

MADRES DE PLAZA DE MAYO

A GROUP OF MOTHERS AND GRANDMOTHERS, WHO MARCH
WEEKLY IN HONOR OF THEIR MISSING SONS AND DAUGHTERS

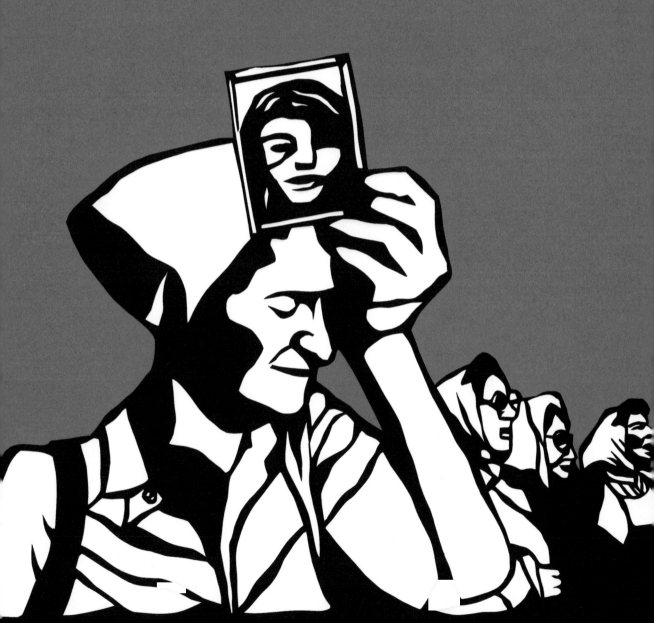

"ONE OF THE THINGS THAT I SIMPLY WILL NOT DO NOW IS SHUT UP."

—MARIA DEL ROSARIO DE CERRUTI, ONE OF THE MADRES

STARTED IN 1977 (BUENOS AIRES, ARGENTINA)

GRACE "GRANUAILE" O'MALLEY

LEGENDARY IRISH PIRATE

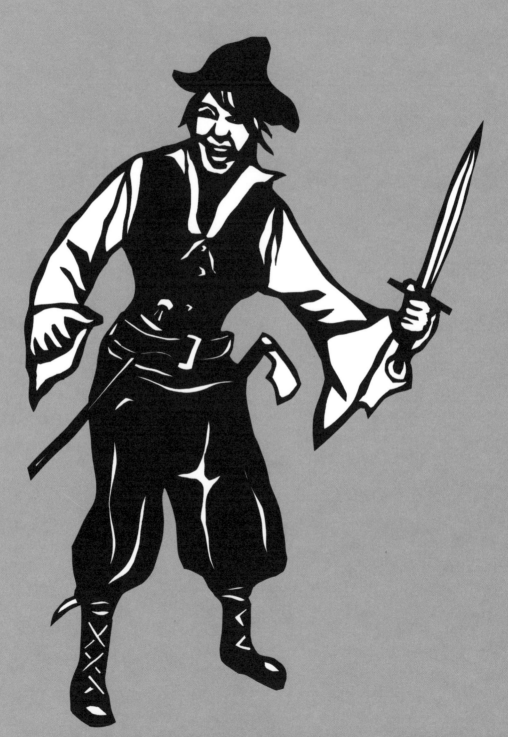

"There came to me a most

FAMOUS FEMININE SEA CAPTAIN CALLED GRACE O'MALLEY...

with three galleys and two
hundred fighting men..."

—LETTER WRITTEN BY LORD DEPUTY SIR HENRY SIDNEY, 1577

GRACE "GRANUAILE" O' MALLEY
1530 (CONNAUGHT, IRELAND)–1603 (ROCKFLEET CASTLE, CLARE ISLAND, IRELAND)

BIRUTĖ MARY GALDIKAS

ANTHROPOLOGIST, PRIMATOLOGIST, AND ORANGUTAN EXPERT

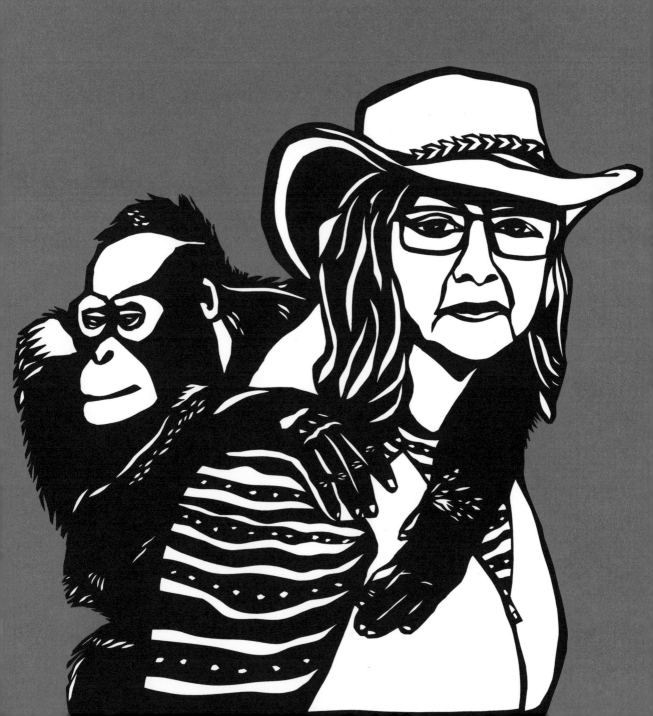

"ALMOST EVERY DAY ORANGUTANS TEACH ME SOMETHING NEW."

—BIRUTĖ MARY GALDIKAS

MAY 10, 1946 (WIESBADEN, GERMANY)

CHIMAMANDA NGOZI ADICHIE

NOVELIST AND WRITER

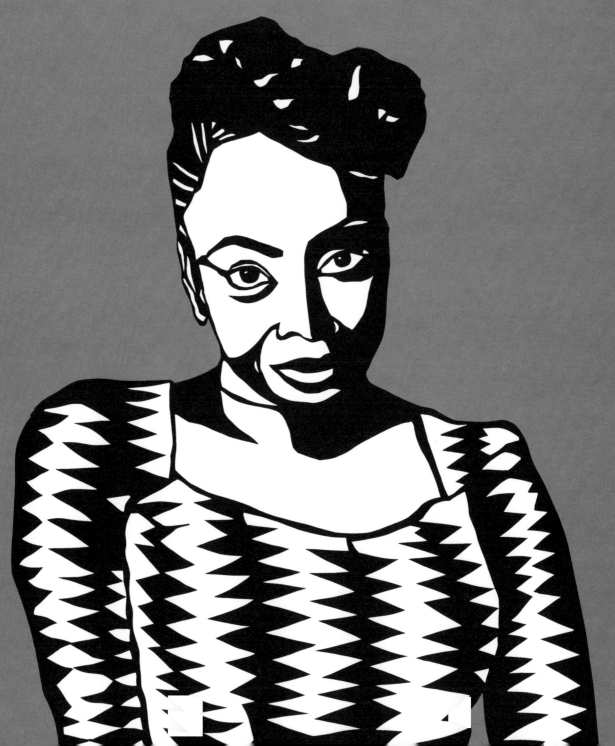

"TO CHOOSE TO WRITE IS TO REJECT SILENCE."

—CHIMAMANDA NGOZI ADICHIE

SEPTEMBER 15, 1977 (ENUGU, NIGERIA)

POLICARPA "LA POLA" SALAVARRIETA

REVOLUTIONARY HERO OF COLOMBIAN INDEPENDENCE

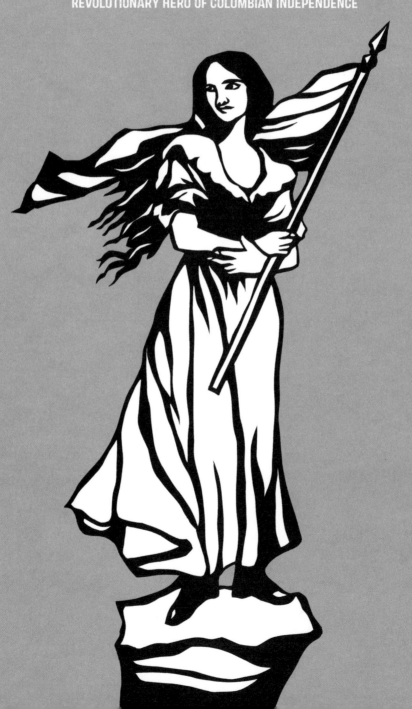

"DO NOT FORGET MY EXAMPLE."

—POLICARPA "LA POLA" SALAVARRIETA

JANUARY 26, 1795 (GUADAS, COLOMBIA)–NOVEMBER 14, 1817 (BOGOTÁ, COLOMBIA)